Hripsime Visser

VAN DER ELSKEN 55

Φ

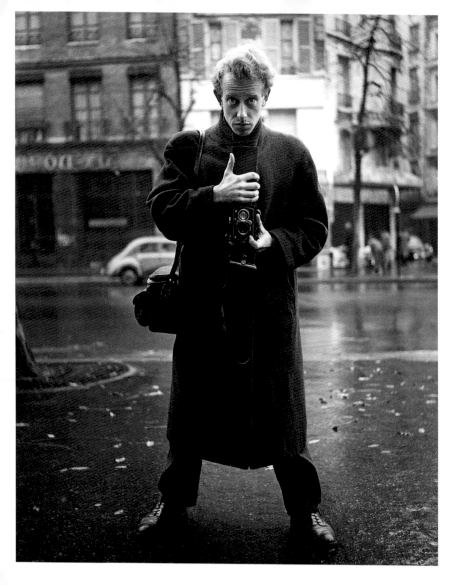

What first strikes the viewer of Van der Elsken's photographs is the gaze of his subjects. In his early work they are often looking away, sometimes pensively, or staring into space. The young photographer observes men, women and children who are deep in their own worlds, in their dreams, their solitude. Later they look back, amused, defiant, self-confident. They have become actors under the command of an adept director, who has a single motto: 'Show who you are.' With those words he ends his last work, the impressive film *Bye*, in which he recorded the progress of his own illness in plain, raw sequences, devoid of false modesty.

What his subjects' eyes have to say is echoed in their body language. The photographer likes bodies, their beauty and erotic aura, their vulnerability and their strength. He sees the play of lure and pose, is constantly discovering yet another form of feminine charm, of masculine ruggedness or childlike longing. Like the sculptor he once wanted to become, he works with mass and volume, with light and dark, with form and spatial effect. Frequently he photographs in colour, but his true vehicle is the black-and-white print, whose expressive potential, whose every nuance — from velvety black to bleached white, from subtle gradations of tone to extreme contrast — he fully exploits.

He was, in his own words, a man with blessed eyes, to some a typical voyeur. But self-recognition remained the prime reason for him to make a photograph. The individuals and situations in his pictures always reflect something of his own emotions. This is not narcissism, and is the absolute opposite of condescension. Ed van der Elsken sought authenticity, and to him that did not necessarily mean 'pure and unspoiled', but rather the full acquiescence of a person in his or her role in life, no matter how pathetic or extreme it was. For this very reason, he

often photographed people on the fringes of society, those not concerned with upholding a position. He recognized their pride and their urge to survive, qualities that he himself possessed.

Van der Elsken had distinct charm but not an easy personality. The demands that he placed upon himself and his environment were high and always directly related to his work. There was a certain inflexible quality about him. He found it difficult to work on assignment, and his judgements of others were often pointed. For Dutch photography of the twentieth century he remains a figure of stature, and his influence on subsequent generations has been considerable.

The quality of his photographs was acknowledged immediately. He had been photographing for only two years when, in 1949, he showed works made during a trip to Paris and Marseilles to a member of the GKf — an association of Holland's photographic elite. Election was by strict ballot but Van der Elsken was accepted without discussion and spent the following year living and working with photographer Ad Windig in Amsterdam. His peer group consisted of the leftist-oriented avant-garde circles surrounding the GKf. He admired the work of the portraitist Emmy Andriesse, who in Van der Elsken's eyes was 'the most artistic of the entire lot'. Andriesse, like Windig and many other members of the GKf, had been involved in de Ondergedoken Camera (the Underground Camera), a group of photographers who had covertly recorded the consequences of the German occupation during the last years of World War II.

During that war Van der Elsken had attended the first year of an art academy in Amsterdam, and then went into hiding in the southern part of the Netherlands in order to escape service in the German labour force. The combat between

Nazi and Allied forces at the end of 1944 was his first painful confrontation with death and violence. After the liberation, as a confirmed pacifist he worked for the mine-disposal squad for a time. By now it was emotionally impossible for him to go back to study. Through trial and error, thanks to jobs with professional photographers and a half-finished correspondence course, he became a photographer.

After World War II, the much-needed reconstruction of the Netherlands was undertaken with incredible diligence and enthusiasm. From a social and cultural point of view, one could speak of a certain blandness, of recovery rather than innovation. The questions of Van der Elsken's generation, who were raised during the Depression years and reached adulthood during World War II, were not answered. The dark facts of the war's history, including the deportation of the Dutch Jews, were not being faced with the sense of guilt that came later. Many young artists felt the climate to be oppressive and departed for Paris, still the centre of culture for Europeans and relatively unscathed by the war.

Ed van der Elsken, too, left for the 'city of lights' during the summer of 1950. Kryn Taconis, Magnum photographer and member of the GKf, provided him with a letter of introduction to Pictorial Service, the Magnum photo laboratory in Paris. Here he printed photographs for the great names of postwar photography: Henri Cartier-Bresson, Robert Capa, David Seymour, George Rodgers and Ernst Haas, whose work he admired greatly. And it was here that he began a relationship with Ata Kando, a beautiful Hungarian refugee and talented photographer who looked after her three children on her own. He kept up his work at Pictorial Service for only six months. By then he was living with Ata

Kando in Sèvres, occasionally having a photographic assignment but for the most part wandering through the streets — looking, talking, taking photographs. Apart from the Dutch *émigrés*, among them the painter Karel Appel and the writer Simon Vinkenoog, he initially knew practically no one.

Then there came a contact: in a café he met a Russian, who dragged him along and introduced him to the bohemia of Saint-Germain-des-Prés — young people of every nationality, all of them marked by the war in one way or another. These were drifters who spent their days in bars, cafés and little restaurants, dazed by alcohol and drugs, desperate, bitter and negative. Van der Elsken photographed them, fascinated by something that he discerned: an outlook on life. Often against their wishes yet, at the same time, as one of them, he captured them drinking, eating, making love and smoking. He had found his style; artificial lighting, smoke and reflections determine the atmosphere. He photographed wild bouts of dancing, arguments and meals but also bodies relaxed in sleep, lost in an embrace, displaying vanity or despair. One of these people was Vali Myers, an Australian artist, a flamboyant personality and the natural centre of male attention. Van der Elsken made wonderful portraits of her, images charged with beauty, intimacy, desire and loneliness.

All of this work was still an unstructured collection of images when Edward Steichen, head of the photography department at New York's Museum of Modern Art, met him in 1953. Steichen was deeply impressed with Van der Elsken's work. 'Ed, this is a story. Why don't you make a book out of it?' Steichen was making preparations for the 'Family of Man' exhibition (1955), later praised and maligned as a platform of postwar humanistic ideology. He included one of Van der Elsken's images in the exhibition and showed his work extensively in

'Post-War European Photography' (1953) at MoMA. The success of that exhibition was followed by others at the Art Institute of Chicago and the Walker Art Center in Minneapolis.

Meanwhile, Van der Elsken had taken up the challenge and arranged the photographs around a narrative written by himself: a fictional and dramatic love story involving Ann (Vali Myers) and Manuel (Van der Elsken's alter ego). In 1956 the book, titled *Love on the Left Bank*, was published simultaneously in the Netherlands, Germany and England, after much ado. There were mixed responses to it. The Dutch middle class in particular was shocked by the negativity and the sombreness of the photographs. The documentary veracity of the works outweighed the fiction of the montage. Like the dreamy, introspective book *Wij zijn zeventien* ('We Are Seventeen') published a year earlier by the young Joan van der Keuken, this portrayal of youth was dismissed with disgust. As often throughout his life, Van der Elsken stood his ground in the face of outright censorship: an initially interested American publisher backed out when Ed absolutely refused to omit photographs of Ann's amorous adventures with black men in a Paris jazz club.

In the reviews of his MoMA exhibition, Van der Elsken was compared to Weegee. Strikingly enough, Weegee's *Naked City* from 1945 is the only book that Van der Elsken ever mentions as being a direct source of inspiration. But Weegee's images of life at the bottom of urban society are those of a concerned reporter. The same people continue to appear in Van der Elsken's photographs, and this suggests an ongoing story. In this sense Van der Elsken is situated somewhere between Weegee and Nan Goldin, the photographer of *The Ballad of Sexual Dependency* and herself a great admirer of Van der Elsken's work.

Both are participants in the generation they portray, though Nan's involvement is more personal. There is another reason for linking the work of Van der Elsken with that of Nan Goldin: the layout of his book has a filmic quality. In the work of both photographers, the idea of exploring and investigating the limits and potential of photography, film and slide projection plays an important role.

By the time that *Love on the Left Bank* ended up in the bookstores, Ed was living in Amsterdam again, initially with Ata Kando, whom he had married in 1954 but divorced shortly after his return to Holland. In Paris he had taken many photographs of Ata and her children, with the idea of producing a book on family life. Dating from that time are beautiful portraits of Ata, often completely exhausted, as well as humorous and gentle photographs of her children. In Van der Elsken's films in particular, such as *Welkom in het leven, lieve kleine* ('Welcome to Life, Dear Little One'; 1963), this form of intimacy, the poetry of day-to-day life, would continue to be expressed in a similar manner.

Amsterdam had changed since Van der Elsken's departure to Paris. The oppressive times of early postwar reconstruction were over, and especially among artists, loose sexual morality and considerable experimentation with alcohol and drugs became prevalent. After his divorce Ed lived with a friend for a time, the journalist Jan Vrijman, with whom he shared work, life and loves. East-coast American jazz, the new rage, could be heard live with increasing frequency. Thanks to Jan Vrijman, Van der Elsken went to his first jazz concert – a performance by Chet Baker at the Concertgebouw on 17 September 1955. A fan from the start, he attended countless concerts in Amsterdam and The Hague until 1959, photographing all the great names of jazz, from Miles Davis to Ella Fitzgerald. In 1959 these photographs were published in a small, square

book of his own design, entitled *Jazz*: grainy prints full of harsh contrasts, images of musicians in total abandon and extreme concentration, again grouped in a dynamic, somewhat filmic rhythm.

Together with Vrijman, Van der Elsken also worked on journalistic assignments during these years (including a famous one on hoodlums for *Vrij Nederland* magazine in 1955), and produced photographs that were published in major Dutch newspapers such as *De Volkskrant* and *Het Parool*. More and more, the Rolleicord of his early years gave way to a Leica with a telephoto lens, and this caused the style and dynamics of his images to change, to become more journalistic. After a somewhat muddled period in his relationships he fell in love with Gerda van der Veen, then a sculpture student, and married her in 1957.

During that same year he set off to Africa at the invitation of his brother-in-law, a civil servant and anthropologist who worked in the Central African Republic. De Bezige Bij, publisher of his first two photo books, paid for his flight and photographic material, with a view to a potential publication based on his trip. Books were always Van der Elsken's pre-eminent platform and he produced more than twenty. All of them bear his mark very clearly. He worked with top Dutch designers but his own contribution was always present, often in accompanying texts but to an equal degree in the selection and layout. Collages of his prints were hung on the walls of his homes. He constantly experimented with the ways in which images reinforce each other, contrast with each other or display a line of thought.

Bagara, an account of Van der Elsken's trip to Africa, was published in 1958. The beautiful book received a very positive response. As one would expect, it

contains no trace of anthropological detachment; he photographed the dramatic highs and lows of Banda village life with the involvement, fervour and poetry that were characteristic of him.

His next book, *Sweet Life*, was proof of his mastery. The photographs, as well as the layout and narrative, continue to impress with their dynamics and beauty. This was published in 1966, roughly six years after a fourteen-month journey around the globe made with Gerda to western and southern Africa, Malaysia, Singapore, Hong Kong, Japan, Mexico and North America. During these travels, and particularly in Japan, he perfected the manner of observation that is so typical of him. Here he becomes not just an observer, but a director. See the difference between the photograph taken in Durban (page 77) and that taken in Osaka (page 85). The first is a crystal-clear record of South African apartheid, heightened by a printing trick that gives the white passer-by a halo, as it were. This manner of printing was in vogue in the Netherlands, particularly during the 1970s. The second image shows a direct confrontation, an almost threatening display of Japanese machismo, a group portrait that could have become fatal for the photographer: an image based on interaction.

Years later, during a radio interview in 1987, Van der Elsken described his method as being analogous to a hunt in which he spotted, from afar, his prey — striking, beautiful or bizarre people — and then stalked them slowly with the telephoto or zoom lens, finally to capture them with a wide-angle lens when they were within reach. The description of that method, including the change of lens, has a certain filmic quality. This is no coincidence. During the same journey around the world, film — with which he had experimented occasionally up to that point — gradually became his second medium. With a film for the

Royal Dutch Shipowners' Association he financed the voyage by boat for both Gerda and himself. A second source of funds was provided by the travel films that he produced with her; these were broadcast on a monthly basis by Dutch television.

Van der Elsken had a difficult time finding a publisher for *Crazy World*, as the book of the journey around the world would be called. Partly due to his frustration about this, he began to film with greater frequency during the 1960s, making a great number of documentaries and television interviews that bear an affinity to cinéma vérité due to a relatively simple and manoeuvrable technique. Like Robert Frank, who began filming at about the same time, he showed a preference for the crude, the unpolished and often the autobiographical. For the Netherlands, Van der Elsken's approach signified a radical departure from existing television, which was directed in a formal manner. In many of his films, he himself plays a major role as an individual and photographer, one example being *De Verliefde Camera* ('The Beloved Camera'; 1971), a self-portrait filmed in part by Gerda for which he received the national prize for cinematography.

In connection with the publication of *Sweet Life* in 1966, the Stedelijk Museum in Amsterdam organized a large retrospective exhibition of his work under the title 'Hee ... zie je dat?' ('Hey ... Did You See That?'). This was to be Van der Elsken's reckoning with and farewell to photography. Fully consistent with the style of the 1960s, it appeared to be one big happening. The entrance consisted of a small corridor whose walls were covered with photographs. In the first room, the voice of a well-known journalist, coming from a gold-paper tent, could be heard reading aloud from a classic manual on photography on the subject of setting up and equipping a darkroom. The tent itself was lined with a

photograph of Ed's darkroom: unprecedented chaos. The exhibition comprised an avalanche of photographs, contact sheets, slide projections and statements by the photographer. The accompanying book, published in seven foreign editions, was just as successful. And so, rather than a farewell, it proved to be a new beginning. Following this he received freelance assignments from the glossy magazine *Avenue*, for which he worked until 1979 doing travel features together with well-known writers. From this work, which was almost always shot in colour on slide film, he later made a selection for the book *Eye Love You* (1977). He said it was 'a people book, women/men book, libido, sex, love, friendship book. A book of happiness, sorrow, suffering, death, conflict, courage, vitality.' The *joie de vivre* and involvement that emerge in this description are characteristic of Ed van der Elsken.

The photographs included in *Eye Love You* express not only delight in various forms of love and lust, but especially indignation, empathy and sincere admiration for the way in which individuals manage to carry on, frequently under unimaginable circumstances. The book is therefore, in a certain sense, the 1970s' answer to the 'Family of Man': a dynamic combination of extreme social developments and phenomena from those years, from the culture of sexual freedom to the dramatic consequences of the famine in Bangladesh. Unlike the 'Family of Man', it is based not on the ideology of equality, but on respect for individuality. Ed was a *bon vivant* but also someone who had a highly developed social conscience. An individualist and anarchist, he was not allied to any political party or action group, though he did produce two television reports on the Third World that led to extensive fund-raising campaigns. The best known of these was a broadcast on the famine in Bangladesh in 1974, a direct result of a photographic assignment for a weekly magazine. *Eye Love You* also became

an exhibition at the Stedelijk Museum, now centred around a slide projection. During this period, Van der Elsken continued to experiment with this form of presentation, far less expensive than film but comparable in impact. A similar urge to experiment gave rise, in 1978, to the uncomplicated and cheerful little book *Hallo*, in which he juxtaposed pairs of colour images from his archives, chosen on the basis of contrast, visual rhyme and humour.

Three major themes give shape to the last decades of Ed's life: a new house and a new love in the countryside just beyond Amsterdam; a growing affinity with Japan, played out through trips, books and exhibitions; and finally the terminal illness that inspired his final masterpiece, the film *Bye*. His marriage to Gerda, with whom he had two children, had broken up at the start of the 1970s. The city-dwelling Van der Elsken went to live on a small farm next to the dyke surrounding the IJsselmeer, near Edam, and turned his back on photography and film for some time. After a lonely period, he began a relationship with the considerably younger Anneke Hilhorst. His inspiration returned, they had a son, and in 1980 he created *Avonturen op het Land* ('Adventures in the Countryside'), a book and a film which sing the praises of life in the country and his new family life in personal, often highly romantic images.

After his journey around the world, Japan and its inhabitants held a special meaning for Van der Elsken. His early images of Japan show a society which is still traditional and insular; this would change rapidly, particularly during the 1970s and 1980s. For Japan itself, his photographs have an exceptional historical value, since no other photographer was working in such a documentary manner at that time. A beautifully printed book of these photographs was published in Japan in 1987. As always, it was unusual individuals who drew his

attention: along with street life, he photographed the machismo of the *yakuzai*, the Japanese criminals, and the rituals of sumo wrestlers and geishas.

Especially during the 1980s, Van der Elsken travelled frequently to Japan, his objective being an extensive book which was ultimately published in 1988 under the title *De Ontdekking van Japan* ('The Discovery of Japan'). In this Van der Elsken shows himself to be fascinated with the increasingly evident distinction between the old Japan and the new way of life influenced by the West and expressed primarily among the young, a theme which he also explored in Amsterdam during the 1980s. The appreciation of the Japanese themselves gave rise to books and exhibitions: many of his earlier titles were reprinted in Japanese editions, and his work was shown time and again. The large retrospective exhibition that travelled shortly after his death, 'Once Upon a Time', was held in Tokyo and Osaka in 1993.

In 1988 Van der Elsken was diagnosed with prostate cancer. Despite the disease that drained him of strength, his will to work remained admirably steadfast. He compiled a book of his early Hong Kong photographs, prepared a Japanese edition of *Bagara* and worked on 'Once Upon a Time'. Two prizes for his entire *oeuvre*, awarded in 1988 and 1990, attested to a continuing growth of appreciation for his work.

In 1989 he decided to make a film about his illness, together with his wife Anneke. This decision involved a special kind of logic, the logic of someone for whom the personal has always been the basis of his work. From December 1989 until June 1990, with extended and brief intervals, Van der Elsken filmed his own physical decline, at home and amid his own family. Usually he is seated in

front of a mirror, so that he can operate the camera himself with some assistance from Anneke. The form is almost consistently a monologue; it is an account of his illness, spoken and filmed by himself, filled with anger and despair but also humour, authority and poignancy. What he allows the viewer to see and to hear is extremely candid, moving and often agonizing. Though barely able to cope with his sadness at times, he never becomes tearful or sentimental. One hears the voice, familiar from his books and earlier films, which expresses his love for life, his anger at injustice. And the voice challenges one to carry out the only lesson that counts for him: 'Show who you are.'

Looking back, one realizes that, along with two other films, *Bye* constitutes a remarkable triptych about his own life. In 1963 Ed had made the film *Welcome to Life, Dear Little One*, which is about the Amsterdam working-class neighbourhood in which he lived, his daughter Tineloe, about Gerda's pregnancy and the birth of his first son. Less than twenty years later, in 1981, he produced part two of this film, focusing mainly on the lives of his two children, who were eighteen and twenty years old by this time. With a hidden camera, he recorded the disintegration of this neighbourhood due to prostitution and drugs. *Bye*, in which his wife Anneke and their young son appear, is the incredibly brave conclusion to this trilogy.

Like all of his photographs, these films portray the great themes of human existence. Van der Elsken has captured them with his singular and immense visual talent. On 28 December 1990 he died. One month later *Bye* was shown at the Rotterdam Film Festival and on Dutch television.

Marseilles, 1949. This photograph – from among the works that sparked off Van der Elsken's election to the elite photographers' association GKf – was taken on his first trip to France. During his Paris years in particular (1950–4) he produced many photographs of people sitting in front of or walking past posters. He liked the alienating effects brought about by the juxtaposition of two different realities. Drawings, paintings and sculptures also appear frequently in his photographs. On the basis of this series he was given the opportunity to photograph for the famous press agency Magnum, but the assignments that he received were not regarded by him as sufficiently stimulating.

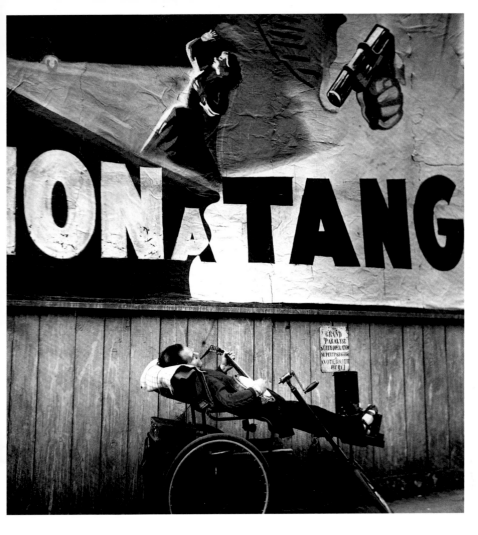

Poor People Living in an Old Lorry, Paris, 1950. Van der Elsken's world was mainly that of the street. People living on the street and people on the fringes of society were among his most important subjects. An early photograph such as this shows the sort of people and situations that touched him emotionally: despite their destitute living conditions, the inhabitants had painted the word ESPERÁNCE ('hope') above the door. The urge to survive that it expressed appealed to him greatly.

Author Simon Vinkenoog with Girlfriend, Paris, 1950–4. Physicality, sensuality and eroticism can be seen frequently in Van der Elsken's work. Vinkenoog, a friend, casually allowed him to photograph these intimate moments with his girlfriend. A great deal of this material was published posthumously in the book *L'Amour*. This photograph also shows the photographer's sense of the sculptural, of the play of bodily forms.

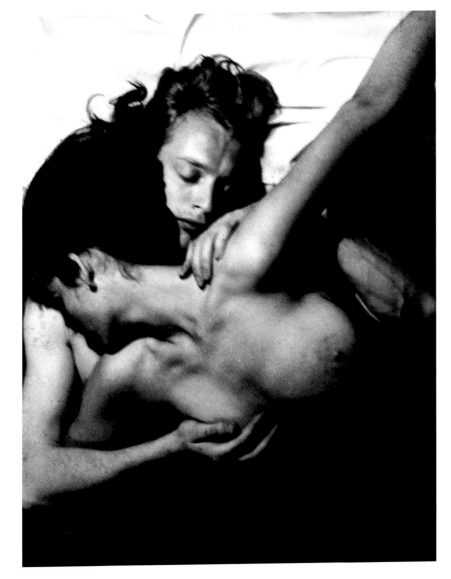

Madeleine Kando Playing 'Patience', Paris, 1950–4. Van der Elsken initially intended to produce a book on his life with Ata Kando and her children. He recorded their day-to-day joys and sorrows at the apartment in Sèvres. This photograph is part of a series, a beautiful study of a child absorbed in play, her pose a variation on Rodin's *The Thinker*.

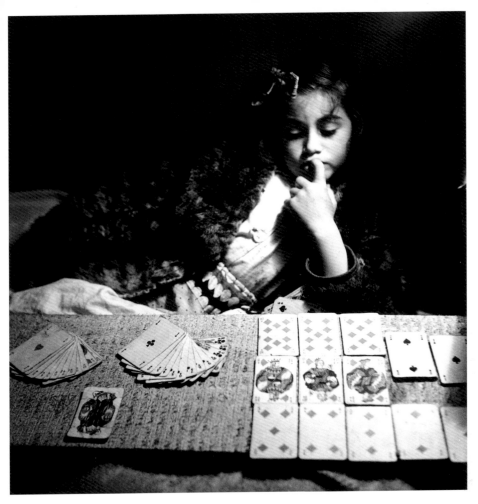

Asleep, Saint-Germain-des-Prés, Paris, 1950–4. Abandonment, through drink, dance, pleasure or, in this case, sleep: it is a cherished theme in Van der Elsken's work. Here is a person relaxing, nodding off on a bench right next to the chaos on a table and, reflected in the mirror to the right, other café guests. It is an interesting composition, built around a considerable contrast between the focused and the unfocused but also between light and dark, the sharp diagonal resembling a division of two worlds.

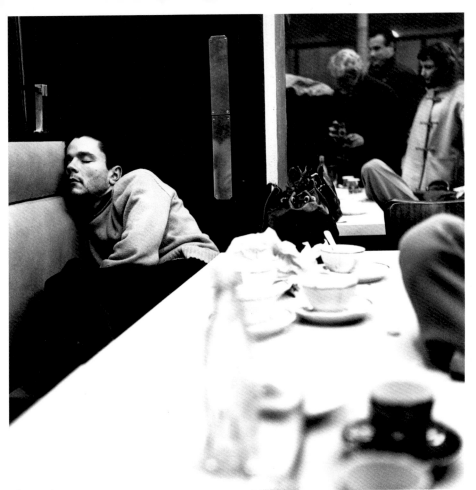

Vali Myers, Saint-Germain-des-Prés, Paris, 1950–4. Women in their interiors: the thoroughly narcissistic concern for one's own body, one's own beauty and personal wellbeing. Van der Elsken was a master in capturing feminine intimacy. Just as with the photographs of Nan Goldin, one is struck by the trust and the openness with which people allow him into their worlds.

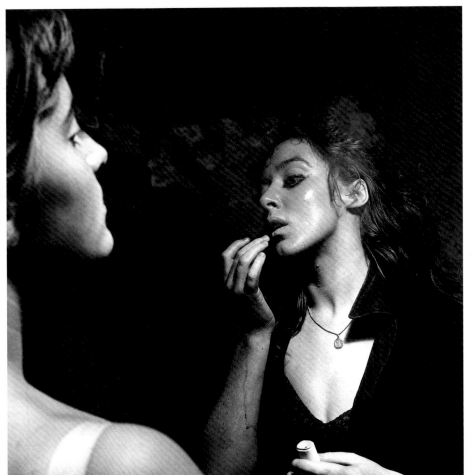

Ata Kando, Paris, 1950–4. One of Van der Elsken's many photographs of Ata Kando from this period. They are among his most moving portraits of women. A number of these were included in the book *Paris 1950–1954*. Those photographs and the accompanying commentaries attest to his respect for Ata as a hard worker and a perseverer. Here, in a penetrating image of submission and despair, she is seriously ill and suffering from a great deal of pain.

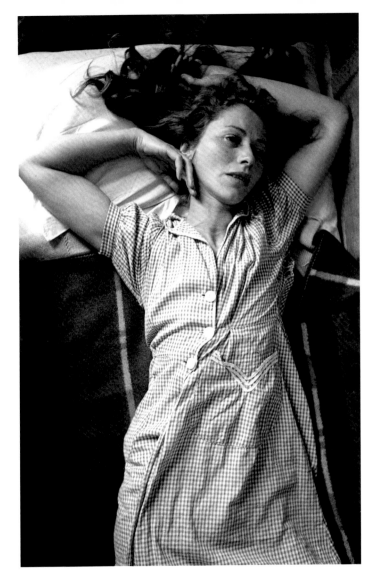

A Glazier, Paris, 1951. This is the result of a typical 'photo hunt', though here Van der Elsken is still a true observer and not the director he later became. According to his own account, he spent a considerable amount of time following this *vitrier*, who was walking through the streets shouting his slogan, but did not capture him, of course, until he happened to be passing the woman with the chairs.

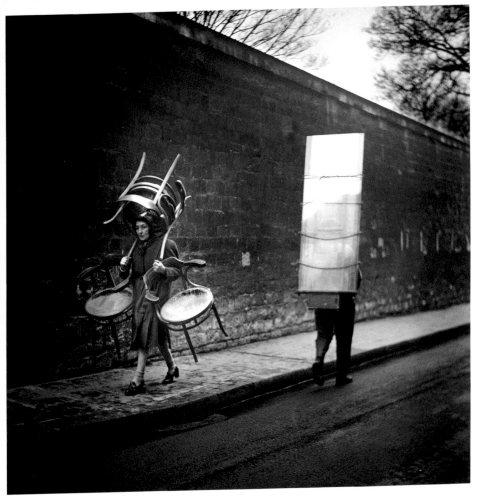

Gendarme on the Boulevard Saint-Germain, Paris, 1951. A gathering of people in the Latin Quarter in Paris, and the face of authority attempting to maintain order. At the centre of the image is a solitary figure – the police officer with his bicycle in the midst of the chaos. This photograph comes from one of the few news reports done by Van der Elsken during this period, a series dealing with a man who was threatening to jump from a building, having already thrown all of his worldly belongings out the window.

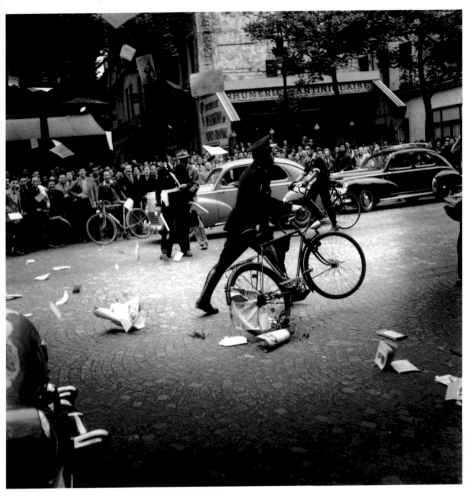

Vali Myers, the Australian Artist, Saint-Germain-des-Prés, Paris, 1951. This photograph is used for the cover of Van der Elsken's first book, the photo novel *Love on the Left Bank*. Vali Myers, who plays Ann, the main character in the book, was his muse for quite some time. On many occasions he photographed her together with her mirror image. Here she is tragic, sensual and unapproachable. In other images she represents an unbridled lust for life, feminine beauty or a deep existential loneliness. In the book, the mirror-portrait in this photograph is juxtaposed with a picture of a more contemplative Ann walking down the street.

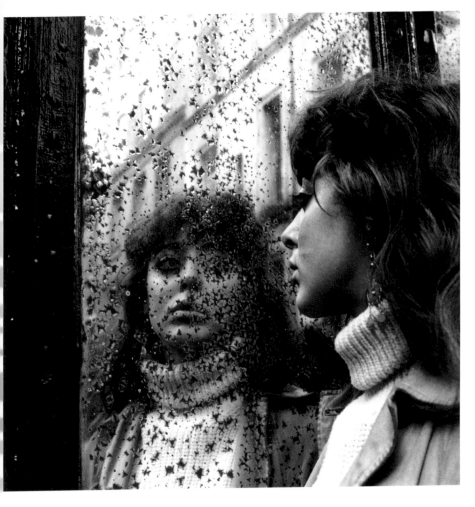

Brigitte Bardot at Studios Wacker, Paris, 1951. This photograph of the young Bardot was a fluke. 'Ata's daughters went to ballet lessons at the professional Studios Wacker. I often went with them. I discovered years later that one of the dancers I'd shot there was Brigitte Bardot. When this picture was taken, she had not yet been discovered' (Van der Elsken in *Once Upon a Time*).

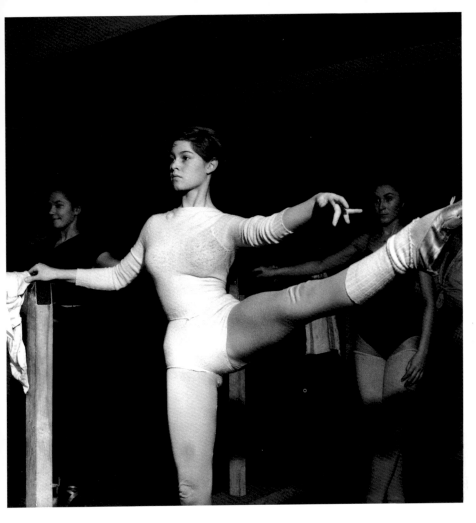

Edward Steichen, Paris, 1953. Van der Elsken's encounter with Edward Steichen, curator of photography at the Museum of Modern Art in New York, was recorded in various photographs. This one deals not so much with the man himself, as with the typical café atmosphere in which Van der Elsken found himself. The suggestive framing directs one's focus to the voracious looks, the drinking and smoking, the sensuality of the female profile, the shine on the glasses.

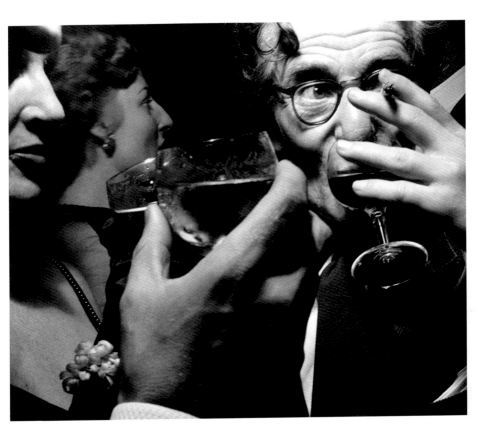

Karel Appel, Paris, 1953. This is a frontal close-up – in Van der Elsken's own words, Appel's 'Stalin portrait'. The painter Karel Appel was one of the *émigré* artists in Paris during those years. He belonged to the group of Dutch painters and writers who made up Ed's circle of friends. In later years Van der Elsken would photograph him more frequently, and in 1961 he also produced a documentary film showing Karel Appel in the act of painting.

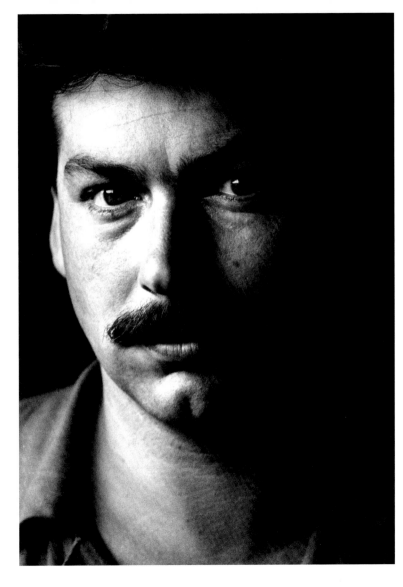

Group in Café Chez Moineau in the rue du Four, Saint-Germain-des-Prés, Paris, 1953. Smoke, reflections, tonal contrast and lively compositions determine the atmosphere of the café scenes in Van der Elsken's photo novel. Next to this shot in his book *Paris 1950–1954* he wrote: 'Chez Moineau. Fred with a cigarette, big and strong, was the righthand man of *chef* ['boss'] Pierre Feuillette. People were sometimes afraid of Fred, but he never hurt anyone. He drank a lot, was involved in one scandal after the other, often "did time" in the Sante [prison]. Mel, the fellow in the duffel coat, was shot dead not long after this picture was taken.'

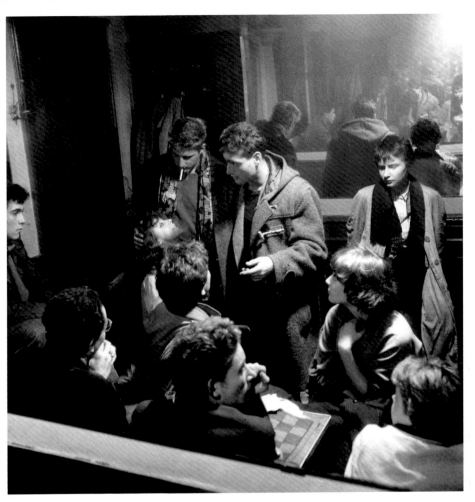

Portrait, Saint-Germain-des-Prés, Paris, 1953. Another photograph from *Love on the Left Bank*, a portrait of one of the *membres de la troupe*. A striking aspect of this picture is the enormous contrast in sharpness between foreground and background. The row of houses serves as the moody setting against which the young woman is photographed frontally and in sharp focus, the expression on her face being ponderous and a little hostile. Her reticence is heightened by the buttoned-up blouse and the rather stiff hairstyle.

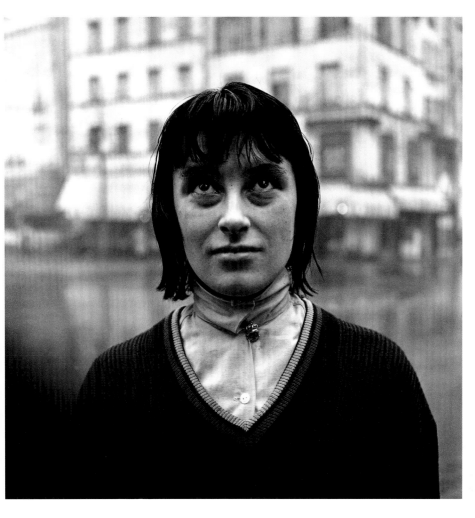

Working-Class Boys from Kattenburg, Amsterdam, 1955. Van der Elsken himself wrote an extensive commentary on this well-known photograph: 'I shot a series to illustrate a story by Jan Vrijman, a journalist. It was about what he called the Nieuwendijk "hoodlums" — lads from working-class families who didn't quite fit with their proletarian background. There is a bit of a story in this particular picture. When they saw their picture in *Vrij Nederland*, the boys said, "Hey, we're not hoodlums, we're working-class boys from Kattenburg," and they refused to allow themselves to be labelled hoodlums. They even sued the magazine *Vrij Nederland*, and won, too. The magazine had to publish a correction. That was a real scandal in Holland in those days. And I hereby declare that they are not hoodlums, despite their tough appearance.'

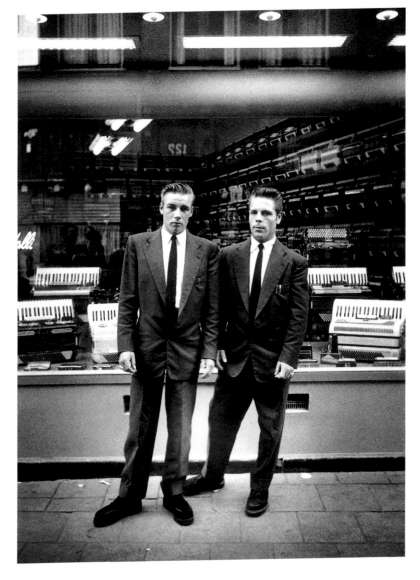

Chet Baker at a Night Concert in the Concertgebouw, Amsterdam, 1955.
Referring to the beginnings of his jazz photography, Van der Elsken once told the following story: 'When I was just back from Paris, my friends told me about a jazz concert, a late-night concert given by the trumpeter Chet Baker at the Concertgebouw. Until then I'd taken little interest in jazz. I went there with a few rolls of film and a camera, and I was so moved, so touched, by Chet's personality and his melancholy music ... I had come back from Paris feeling pretty melancholy anyway, and I was still in that mood in Amsterdam at the time. After that I went on shooting jazz for another four or five years.'

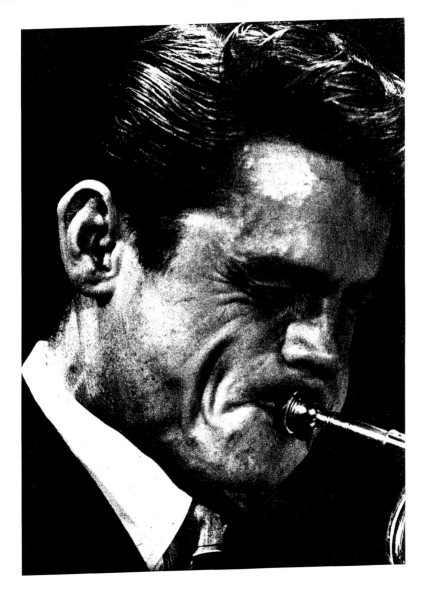

Louis Armstrong at the Concertgebouw, Amsterdam, 29 October 1955. Both this photograph and the previous one show the intense concentration of the musicians. This sparingly lit close-up focuses solely on Satchmo's passionate, highly expressive face.

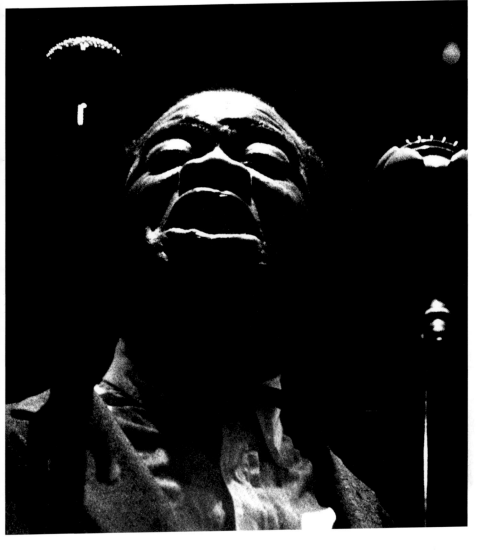

Girl with a 'Beehive' at the Fair on the Nieuwmarkt, Amsterdam, 1956. This photograph is the Dutch counterpart to the portrait on page 45, the girl in the Paris street. Here, too, the city is the setting, this time with the streaky light of streetlamps and neon signs, shot at night with a relatively long shutter time. This abstract background is juxtaposed with the staring young woman, quite the fashion with her blonde 'beehive' and streamlined glasses, the hands held in a precious gesture at the knot of scarf beneath her chin.

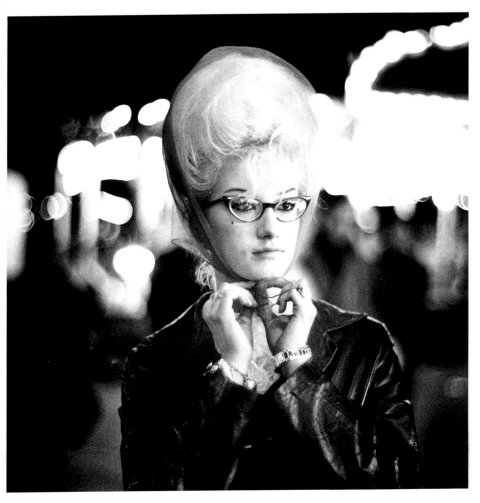

Larking around at the Fair, Amsterdam, 1956. The play of attraction and rejection, the flirting and cavorting of boys and girls is frequently photographed by Van der Elsken. He liked the poses, the body language involved in these games. This photograph and the previous one were taken with a Leica which had a very fast lens – in Van der Elsken's words, 'one that could still give you a perfectly lit negative and a beautifully unfocused background'.

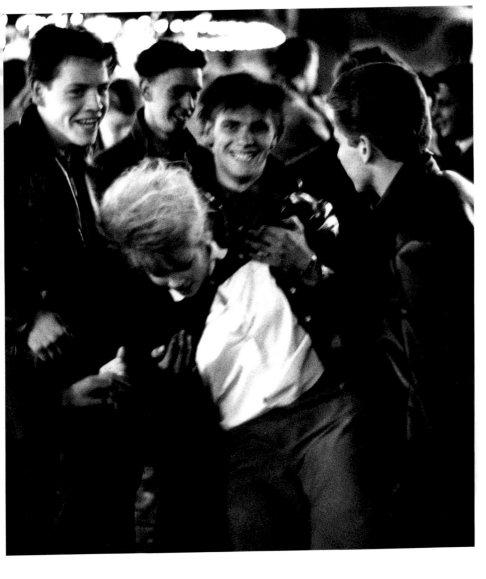

Visitors to the Cotton Club, a Jazz Club on the Groenburgwal, Amsterdam, 1956. This is a shot of Dutch girls, young men from Surinam and American soldiers on leave. Here again is that infallible instinct for body language. Van der Elsken clearly spotted this group because he found them beautiful; he undoubtedly called out to them since they are posing to a certain degree, distracted from their usual behaviour for a moment, though this is less explicit than in his later, more 'directed' photographs.

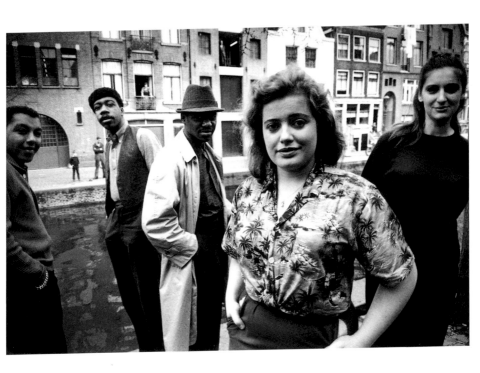

The Audience at a Concert of the Lionel Hampton Big Band, The Hague, 1956.
Now and then Van der Elsken would aim his camera not at the musicians but, as here, at the wildly enthusiastic audience. The centre of the composition is once more a loner, the quiet figure of authority, controlling himself in accordance with his role in these surroundings.

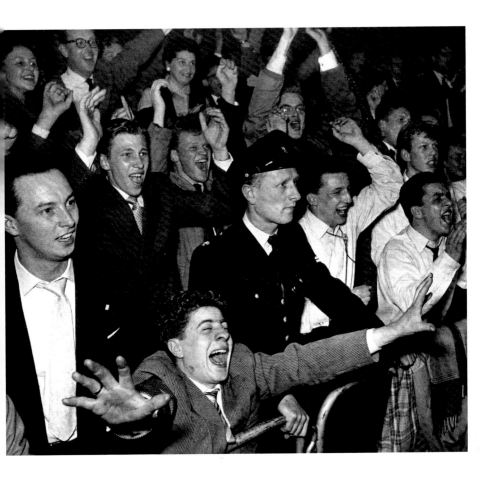

Ella Fitzgerald at the Concertgebouw, Amsterdam, 1957. 'As you can see, this is a rather grainy picture. It wasn't deliberate. I would just as soon have had the picture fine-grained, but we had to shoot with the available light: flash wasn't allowed. We experimented with very little light and films that weren't very fast. You had to push-process these to produce a decent picture. I remember mine were underexposed at first, and I had to intensify the barely visible negative afterwards in the darkroom, yielding an extremely grainy negative which I really like now. I appreciate the graininess now, but it wasn't intentional.'

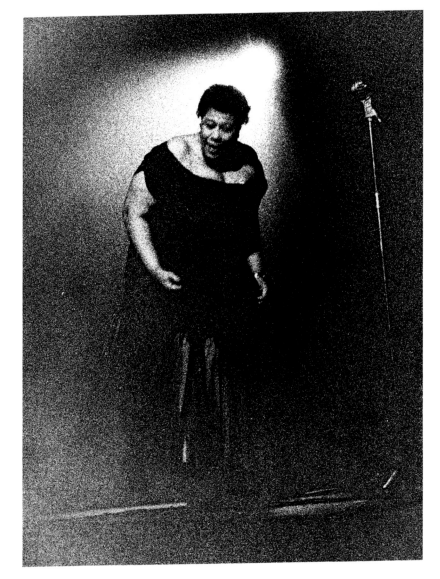

Ceremonial Dance, French Equatorial Africa, 1957. During his first trip to Africa, Van der Elsken photographed various rituals in addition to scenes from the day-to-day life of the Banda tribe. Just as in *Love on the Left Bank*, he endeavoured to photograph as a participant. By actually mingling with the dancers, he has recorded their trance and ecstasy in an almost subjective manner.

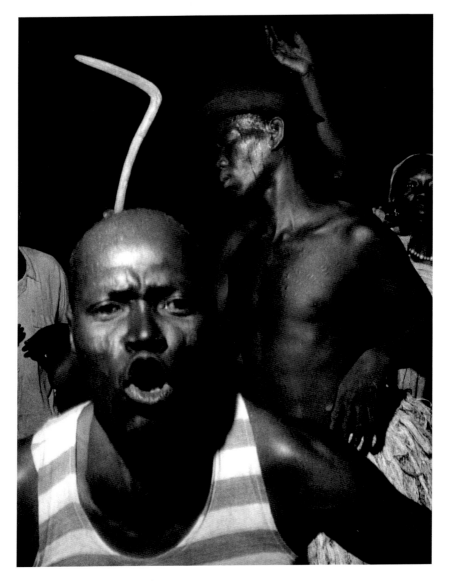

Hunting Expedition, Province of Oubangi Chari, French Equatorial Africa, 1957.
Van der Elsken took part in various hunting expeditions. In interviews he has said that, despite his pacifist convictions, he was totally spellbound by the excitement of the hunt and the will to kill. This photograph shows two white hunters and a black tracker. Here the buffalo in the distance has been hit but not killed. They managed to achieve this only after a long, dangerous trek.

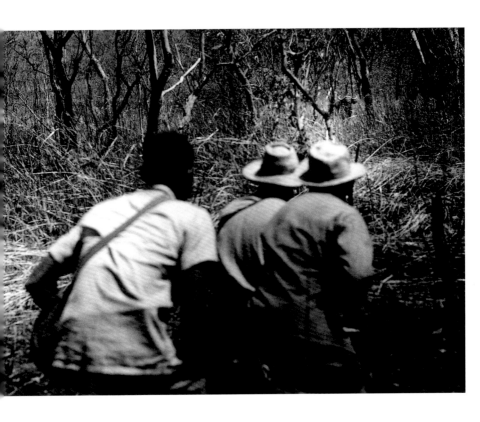

Wailing Women Ritually Mourning the Deceased, French Equatorial Africa, 1957.
Van der Elsken extensively recorded the rituals surrounding the funeral of a
village inhabitant. In his book *Bagara*, it forms part of a dramatic sequence of
images that show the *pleureuses*, women whose impressive lamentations could
be heard for hours.

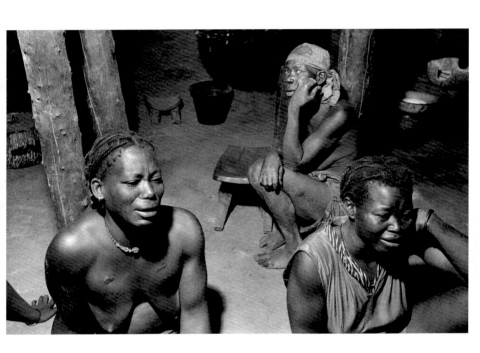

The Landlady of a Bar on the Oudezijds Achterburgwal near Central Station, Red-Light District, Amsterdam, 1958. During the 1950s in particular, Van der Elsken took many photographs in his own neighbourhood – the old centre of Amsterdam. He preferred to photograph working-class life and people such as this matron, a tower of strength amid city life and its transient figures.

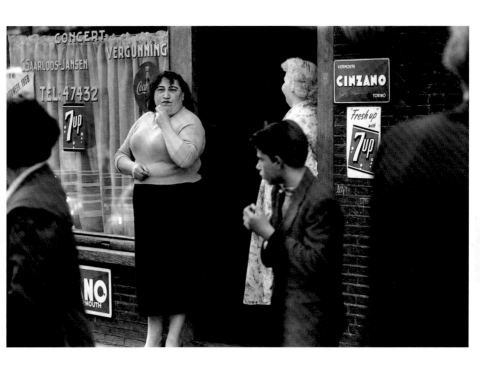

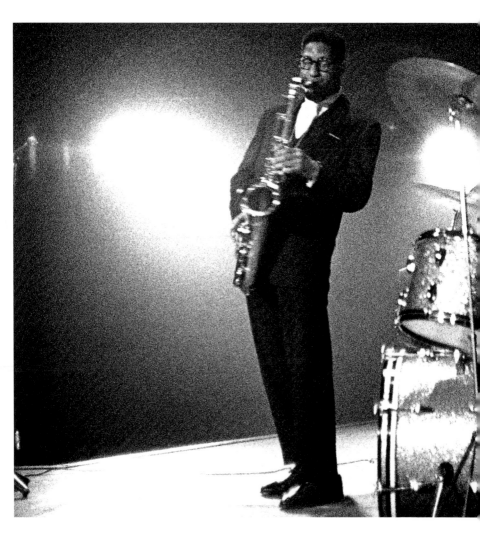

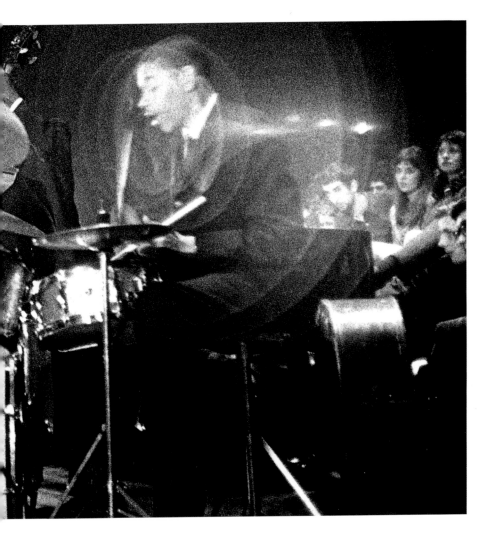

(previous page) Sonny Rollins at the Concertgebouw, Amsterdam, 1959. All of Van der Elsken's jazz pictures are concerned with the musicians' complete involvement in music-making. Here the fun of playing jazz is evoked in the halo of light that surrounds the drummer. Van der Elsken loved this kind of dark-room trick.

Man and Machine, Nigeria, 1959. In 1959 and 1960 Van der Elsken made a fourteen-month journey around the world together with his wife Gerda. Their first stop was West Africa. The straightforward title of this picture – one of his most famous – aptly describes the striking bond it portrays. The elegant and almost reverential way in which the man approaches the machine is both humorous and moving.

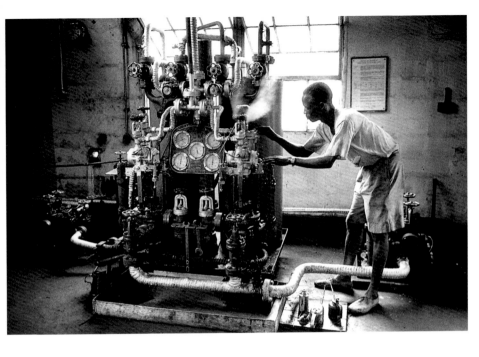

Fishing at the Coast, Aberdeen, Sierra Leone, 1959. This photograph comes from an extremely lively, almost film-like account of a 'flying-fish' catch. Van der Elsken has concentrated on the suppleness and the technique, the elegance and the strength of the fishermen.

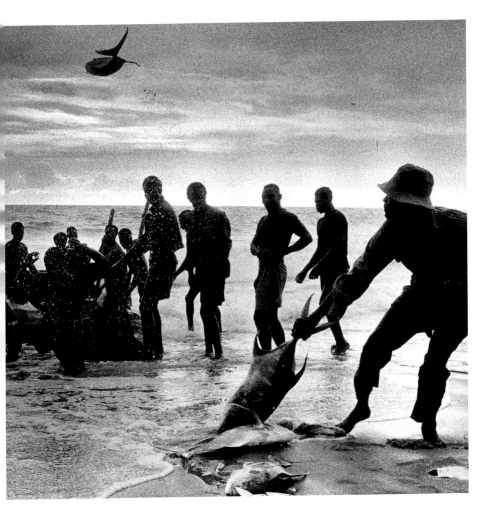

Durban, South Africa, 1959. Van der Elsken showed his anger about apartheid in the suggestive way he printed this image, and expressed it in the following caption: 'The sea in Durban on the east coast of Africa – the sea in which the black Africans are not allowed to bathe; if a negro feels tired, he can't sit on a bench. That's the way the Christian whites, the chosen few, the members of the superior ladies-and-gentlemen race want it.'

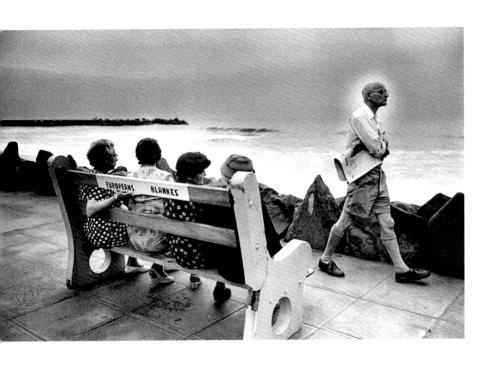

Chinese Cargo Boats in the Harbour, Hong Kong, 1959–60. Only on a few occasions did Van der Elsken record this type of cityscape. The island, the city with over a million inhabitants, the phenomenon of Hong Kong, fascinated him profoundly. The many photographs in his archives can also be regarded as having exceptional historical significance. Towards the end of his life, he used these early works to compile a book about Hong Kong that was published posthumously.

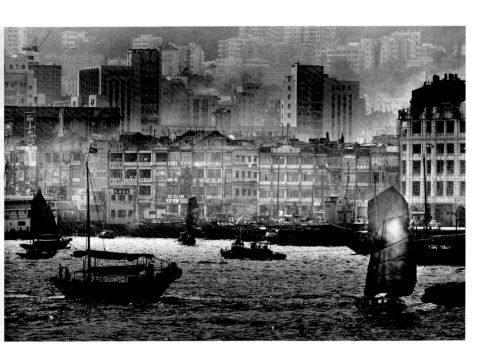

Rickshaw, Hong Kong, 1959–60. Van der Elsken was always fascinated by the way in which people tried to make ends meet. As is often the case in his work, this image is constructed around a contrast: the busy, shuffling masses of the city versus the loner in his tragicomic role as passenger and burden. He is the only figure in the image to be singled out from the drabness of the masses, though the meaning of his upwardly directed gaze, precisely in the centre of the composition, remains obscure.

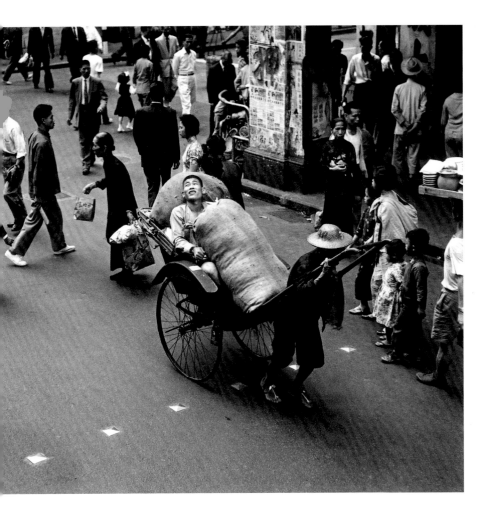

Sequence, Hong Kong, 1959–60. These consecutive shots by Van der Elsken 'the hunter' have the effect of film stills. 'I saw a girl coming towards me from the docks, off the ferry. She looked gorgeous and sexy, even to me – for I still had to get used to the way they dressed. Their dresses with the split skirt are called *cheong-san*. I walked along beside her taking pictures – she was a bit peeved, but still, that's life – until I finally had my picture.'

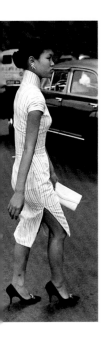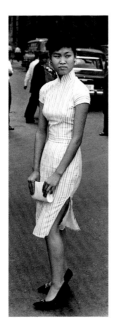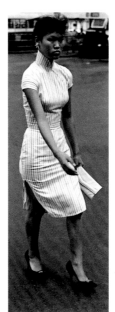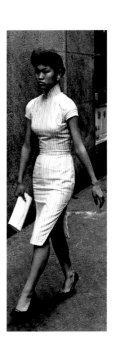

Young Yakuza Gangsters, Osaka, 1960. In Japan Van der Elsken became more and more the director: 'I seem to recall that I told them what they had to do in Dutch – the tone of your voice is part of your body language. They posed, I took two shots. One was blurred ... Their fashions and poses were inspired by Chicago gansters, Al Capone style.'

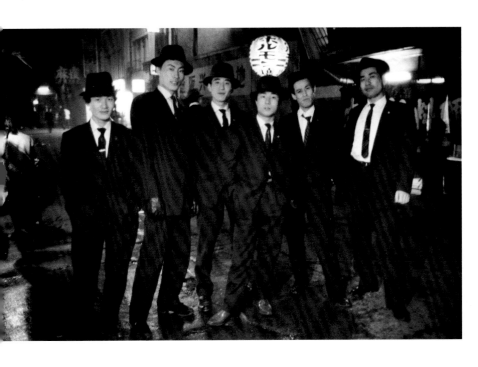

Lovers, Guadalajara, Mexico, 1960. The body language of people in love
observed with great gentleness. Van der Elsken's archives are full of photo
graphs showing tenderness between people, from his early work in Paris to his
last pictures in Japan.

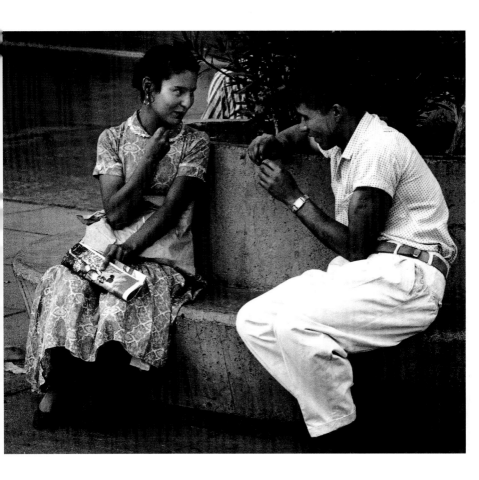

Call and Ruby Black in Front of their Museum, Mojava Desert, USA, 1960.
Unusual people, unique situations: Van der Elsken had a keen eye for these. This is his portrait of a sculptor and his wife in front of their peculiar museum in the middle of the desert, miles from any other houses. In a strange way, this photograph is actually a pendant to the previous one. 'Look at them standing there, hand in hand. They really do love each other.'

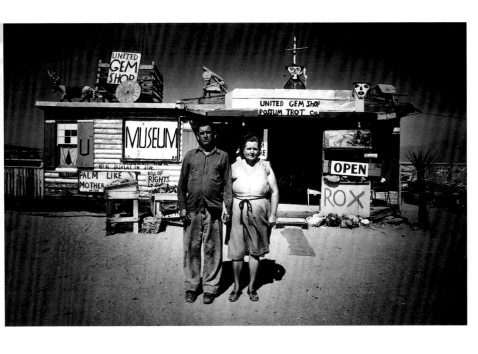

Beach at Coney Island, New York, 1960. 'I learned to love the Americans on Coney Island. Truly, madly, affectionately. What you see here is so endearing, so ordinary and heart-warming … fat people with painful feet and teenagers going around flirting; horrible menaces and hoodlums; really cool negro lads and white lads, too … It's all so elementary, so down-to-earth, the way it is the world over – small people with a lot of worries and a little bit of happiness.'

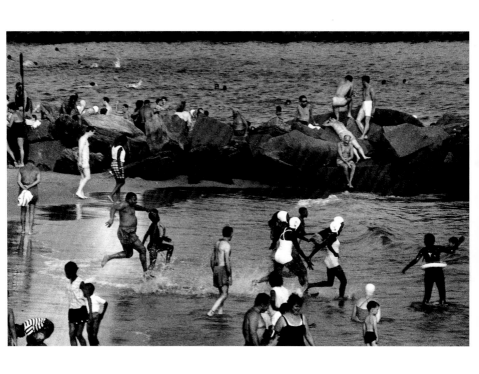

Johannesburg, South Africa, 1968. A study in the roles of the sexes. Van der Elsken has chosen a position in his characteristic way: on the one hand, he is looking on with the group of girls, but at the same time his own identity is reflected in those of the young men.

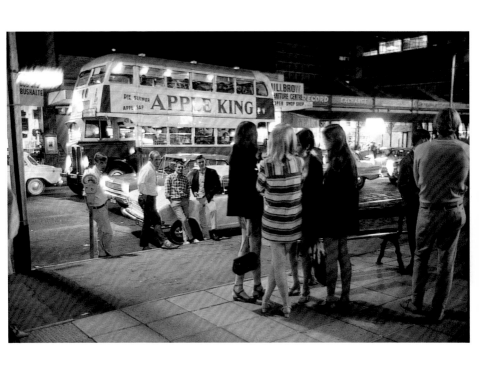

Tourists Taking Photographs, South Africa, 1968. Like the previous photograph, this was from one of the travel reports made by Van der Elsken for the glossy magazine *Avenue*. It shows a mild ridicule of the attitude of the typical tourist, the meaning clear but the approach full of humour. This is typical of the way Van der Elsken cloaked his criticism: it was almost never outspoken but always done with a smile.

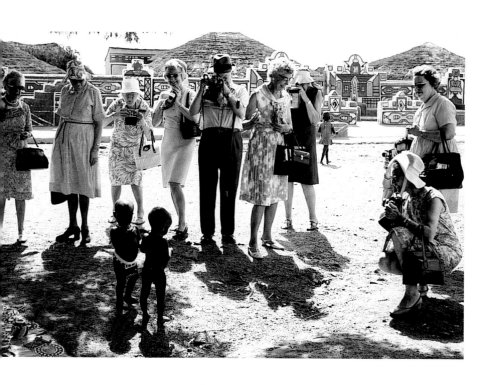

Cowgirl, India, c.1968. Possessed of a considerable pride and *joie de vivre* himself, Van der Elsken was quick to recognize this in others. To him, the strength and the delight conveyed by this cowgirl dressed in tatters symbolized hope. The photograph is part of the final sequence of *Eye Love You*, which he introduced with a paragraph on vitality and on the capacity of people to survive despite war and misery. 'Look at the people on the last pages of the book. Often they are destitute, deprived toilers. But they shine. They're beautiful and gentle.'

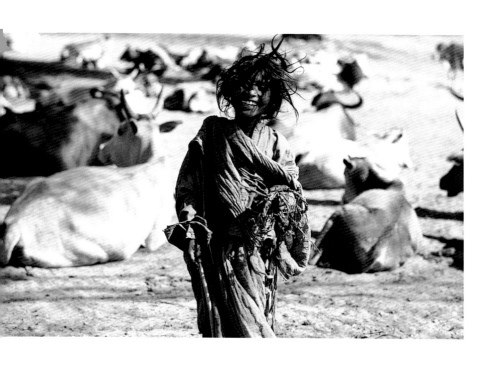

Beach at Zandvoort, The Netherlands, 1970–5. In his book *Eye Love You*, Van der Elsken spread this photograph across two pages. It forms part of a sequence on nudist beaches, and his caption reads: 'Two couples, the young people nice and the old people just fine, too. That man still looks dignified in his underwear.'

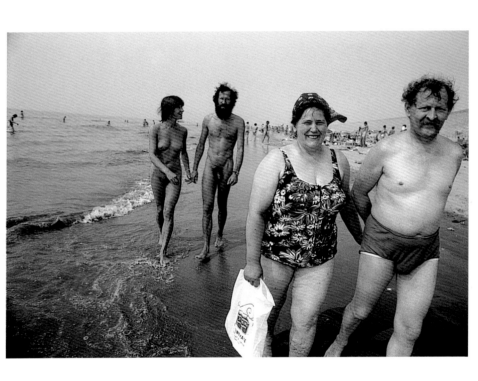

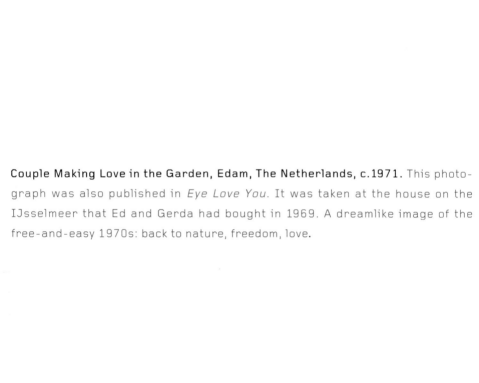

Couple Making Love in the Garden, Edam, The Netherlands, c.1971. This photo-
graph was also published in *Eye Love You*. It was taken at the house on the
IJsselmeer that Ed and Gerda had bought in 1969. A dreamlike image of the
free-and-easy 1970s: back to nature, freedom, love.

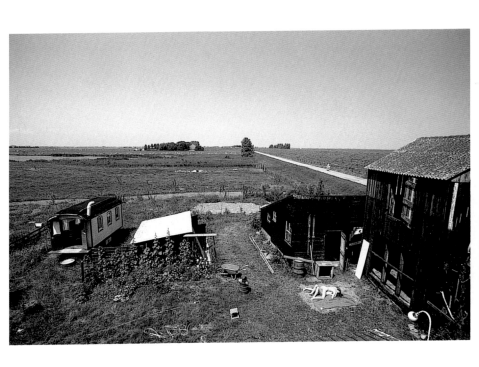

Vali Myers, 1972. In 1972 Van der Elsken made a documentary for Dutch television on his old muse Vali Myers, who by this time was living as a hippie in a valley near Naples with some animals and a young lover. To Ed she epitomized an enviable sort of autonomy. In *Eye Love You* he wrote alongside this portrait: 'Demonstrating against stupid, ugly, undignified things can be done in many ways. Political, guerilla, mass movements. But you can also go through life on your own, as a striking, defiant flash — as a beacon, a whirling point of recognition. One person who does that is Vali Myers, Australian artist, painted up, tattooed, irritating and inspiring to all.'

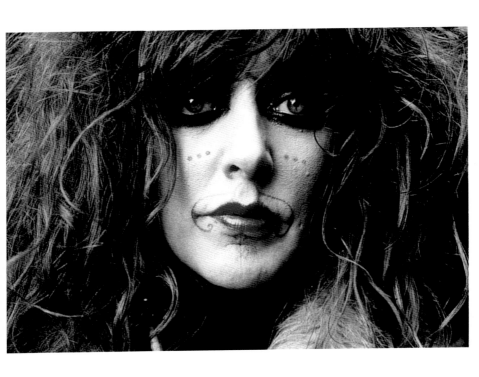

Famine following Catastrophic Floods, Dacca, Bangladesh, 1974. This is an exception in Van der Elsken's body of work. His despair about the situation is plainly reflected in this child's face, marked by hunger. It comes from one of his few reports of the 1970s to deal directly with social issues.

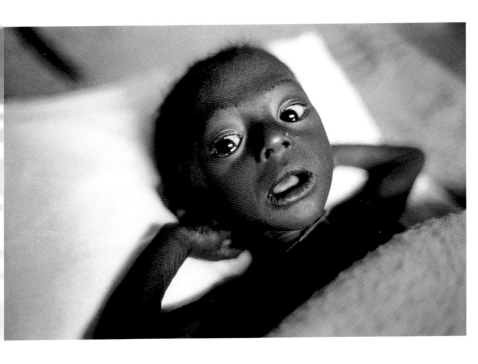

Ed van der Elsken's Son, Daan Dorus, with his Mare, Pravda, near their Farmhouse, Edam, The Netherlands, 1975. Van der Elsken photographed his children frequently and he had a perfect sense of their emotions. The intensity of the boy's relationship with his horse is almost tangible. Most of Van der Elsken's subjects incited him to try to provoke a reaction, whereas children (and animals) were allowed to stay in their own world, one divorced from the harshness of reality.

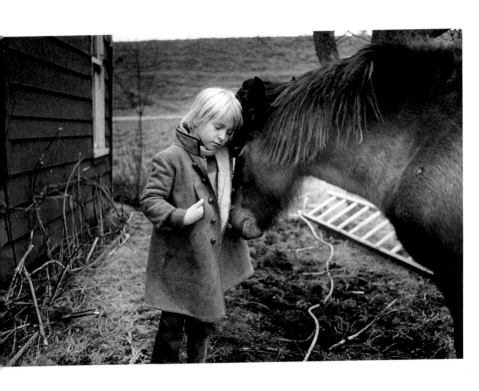

Boys with Swan, Province of Noord-Holland, The Netherlands, 1975. This shows another aspect of freedom in the countryside: tough kids on a motorcycle have caught a swan and will probably take it to the butcher in exchange for a considerable sum of money. It is proof of Van der Elsken's speed in reacting to situations that make a good image, a good story.

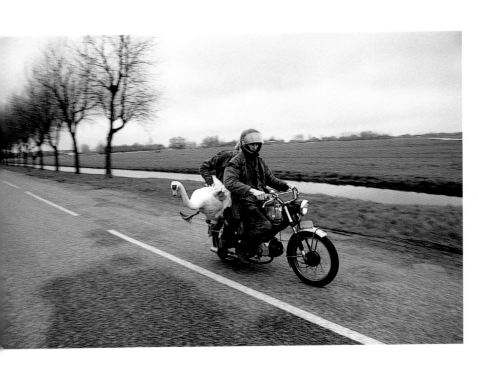

Horses Pravda and Fidelito, Edam, The Netherlands, 1978. As early as his first trip to Africa, Van der Elsken was producing unusual photographs of animals. That fascination returned in Edam. For some years he bred horses, and they play a key role in the film and the book *Adventures in the Countryside*. Here they are photographed in a mysterious *ton sur ton*.

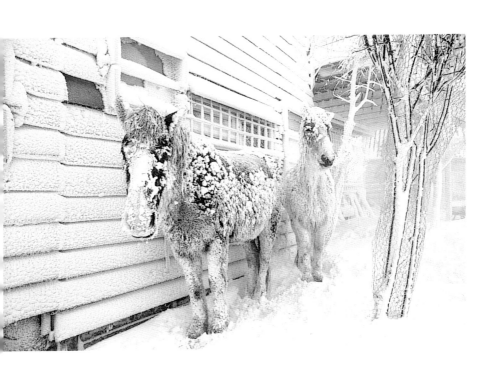

Kiss on the Corniche, Marseilles, 1981. One of Van der Elsken's countless images treating the various forms of love and lust. Characteristically there is total abandon, complete and shameless fusion, yet at the same time there is something uncanny in the long fingers with their green nails that lovingly embrace a bare shoulder.

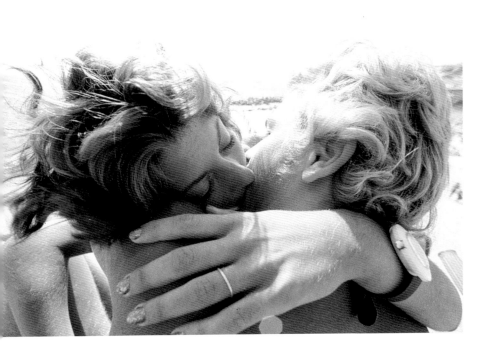

Two Hookers being 'Walked' by their Madam on Bastille Day, Marseilles, 1981.
Author Willem Jan Otten once wrote a short piece on the particular way that many of Van der Elsken's subjects look at him: 'It is a gaze which, as far as I know, nobody ever directs at me. However, it can be seen frequently in Van der Elsken's work and comes from many different types of people, not only women … Many times he succeeded in having people look at him in such a way that his irresistibility was proven … He captures the moment at which [the subject] becomes aware of him and gets involved and eroticized.'

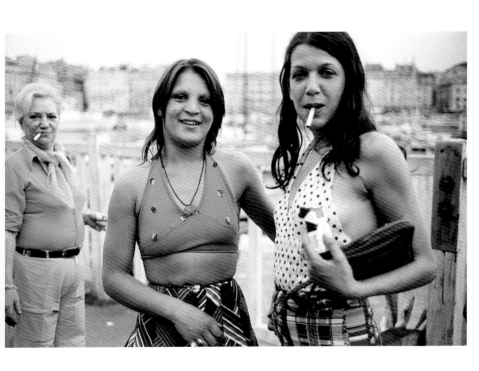

Girl in the Underground, Tokyo, 1981. Van der Elsken travelled to Japan on many occasions during the 1980s for a book that would be published in 1988 under the title *De Ontdekking van Japan* ('The Discovery of Japan'). As always, he is fascinated with the posture of people, with poses, with body language. The girl in the middle of the image exudes a certain superfemininity; the look in her eyes suggests self-awareness, a degree of curiosity, and defensiveness. The contrast between her finely focused appearance and the unfocused background is reminiscent of Van der Elsken's early photographs of solitary women in Paris and Amsterdam.

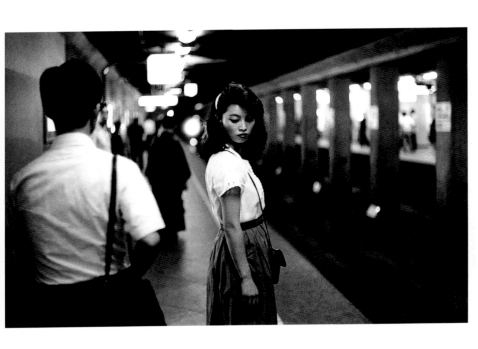

Boys in the Reguliersdwarsstraat, Amsterdam, 1983. In 1983 Van der Elsken was granted his own photo column, called 'Ed's Amsterdam', in the city's newspaper *Het Parool*. Just as in the film *Een fotograaf filmt Amsterdam* ('A Photographer Films Amsterdam'), he dared people to smile, to strike an exaggerated pose. During this period in particular, he played the role of director to the hilt.

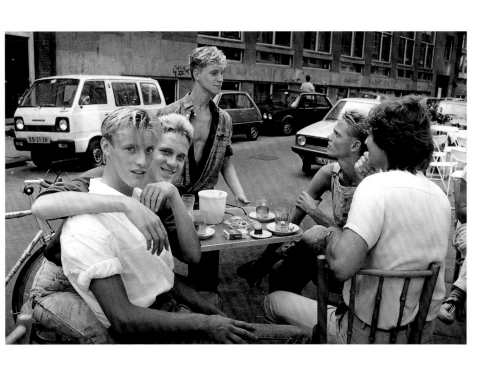

Punks, Amsterdam, 1983. During the early 1980s Van der Elsken made a film in which his teenage children figure prominently. There he displays, as in this photograph, an equally keen sense of the (un)certainties of youth. Once again there is that special gaze — the way in which the supposedly tough punks look back at the photographer, and at us, the viewers.

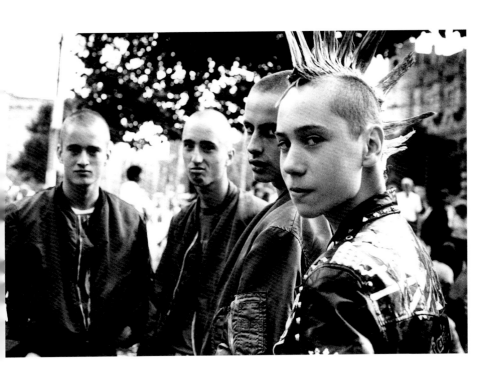

Transsexuals, Tokyo, 1988. 'Sunday morning at eight o'clock, at a broad zebra crossing leading to Kabuki-cho. On the other side of the road, I see three rather elegantly dressed ladies coming towards me. There was something about them that intrigued me. I dashed up to them and said, "Girls, would you mind me getting a really good shot of you?" I think that's what I said to them in Dutch. "Why, not at all, sir," they answered, or something to that effect, and *whoops* ... the blouse was whisked off, the cocktail dress eased down and bare breasts pointed at the camera. I shoot a few pictures. Somehow something isn't right. Shrieks of laughter, giggles, tarty behaviour. Half-dressed in the middle of the street. Very un-Japanese. Then, in a grossly obscene gesture, one of the ladies sticks her finger up the backside of one of her companions ... and then I know for sure: men, transsexuals! They'd really got me there, and I thought I was sophisticated, that I was streetwise! Thank you, ladies!'

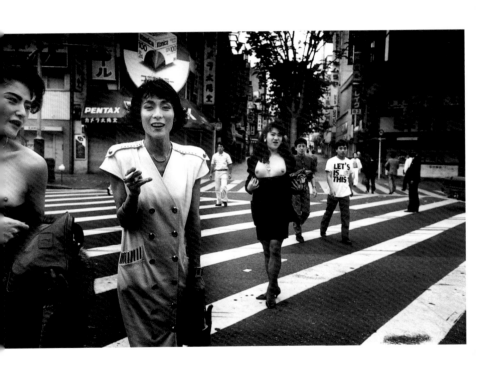

Prostitution in the Back Streets of Itaewon, Seoul, Korea, 1988. At the end of the 1980s Van der Elsken received an assignment, from his Japanese publisher, to produce work for a book on Korea. After an initial trip, he became ill and was unable to travel any longer. This is one of the shots he took on that last trip to the red-light district of Seoul. In *Once upon a Time*, his final book, Van der Elsken writes extensively about a photograph that he saw but, to his great regret, did not take: an image of another red-light district with groups of identically dressed, beautiful prostitutes. It is with this story, presented as a tip to a fellow photographer, that he concluded his final work.

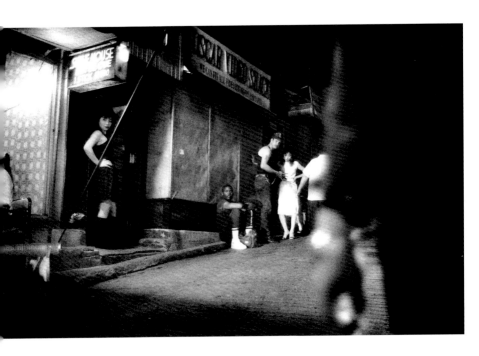

1925 Eduard (Ed) van der Elsken born on 10 March in Amsterdam.

1943 Studies sculpture at an art college in Amsterdam, but is forced to leave the school due to the German occupation.

1944–1945 Goes into hiding in the south of the Netherlands; joins the Allied liberation troops after the Battle of Arnhem.

1946–1947 Takes a correspondence course with the School of Professional Photography in The Hague, but fails the exams.

1947–1949 Takes his first street photographs in Amsterdam with his father's camera. Acquires experience working for other photographers and taking pictures during his first trip abroad. His pictures of Paris and Marseilles are enthusiastically received by the GKf, the most important photographers' organization in the Netherlands.

1950–1951 Moves to Paris; works in the darkroom of Pictorial Service, the laboratory of the Magnum photographers, where he meets Ata Kando. First becomes involved with the café life of Saint-Germain-des-Prés. These photographs of bohemians later appear in his pictorial novel *Love on the Left Bank* (1956).

1953 Meets Edward Steichen, curator at the Museum of Modern Art in New York, who selects eighteen of Van der Elsken's photographs for the exhibition 'Post-War European Photography' in New York.

1954 Marries Ata Kando.

1955 Returns to Amsterdam and produces a series of photo-stories for the magazine *Vrij Nederland*. Begins making films with the journalist Jan Vrijman. Divorces from Ata Kando.

1956 Leaves for French Equatorial Africa. His photographs are later published in the book *Bagara* (1958).

1959–1960 Takes a 14-month trip around the world with his second wife, Gerda van der Veen. To cover costs he makes film reports for Dutch television.

1962 Disappointed by the difficulties of publishing a book about his trip, he stops taking photographs for five years.

1963 Makes the film *Welcome to Life, Dear Little One*.

1966 Photographs from his world trip are shown at the Stedelijk Museum, Amsterdam, in the exhibition 'Hey ... Did You See That?'.

1966–1979 Working on travel features for the magazine *Avenue*. Films two documentaries in Bangladesh.

1971 Moves to a farm in Edam. Country life begins to play a more important role in both his photography and his films. He receives the Dutch National Film Award for *The Beloved Camera*.

1977 Travels to Asia, the Far East and South America with Anneke Hilhorst, whom he marries in 1984. The frequent use of colour in this period results in his first book in colour, *Eye Love You* (1977).

1980 The film *Adventures in the Countryside* and accompanying book are released. Makes various films in the following years.

1984–1988 Spends much time in Japan, where he has a large exhibition in Tokyo. The Dutch Ministry of Culture awards him a grant to complete a book on the country; *The Discovery of Japan* is published in 1988. On returning from a trip to Korea he hears that he is suffering from cancer.

1989 Following surgery, he continues to feel the urge to work. He makes the film *Bye*, which deals with the progress of his illness, and works on a book about Hong Kong (published in 1997).

1990 Van der Elsken dies on 28 December in Edam.

1991 The Stedelijk Museum in Amsterdam holds the retrospective exhibition *Once Upon A Time*, which later travels through Europe and Japan.

Photography is the visual medium of the modern world. As a means of recording, and as an art form in its own right, it pervades our lives and shapes our perceptions.

55 is a new series of beautifully produced, pocket-sized books that acknowledge and celebrate all styles and all aspects of photography. ·

Just as Penguin books found a new market for fiction in the 1930s, so, at the start of a new century, Phaidon **55**s, accessible to everyone, will reach a new, visually aware contemporary audience. Each volume of 128 pages focuses on the life's work of an individual master and contains an informative introduction and 55 key works accompanied by extended captions.

As part of an ongoing program, each **55** offers a story of modern life.

Ed van der Elsken (1925–90) was one of the great documentary photographers of the 1950s, 1960s and 1970s. Inspired to become a photographer by Weegee's book *Naked City*, his pictures often dwell on the darker side of human existence. In 1950 he moved from his native Holland to Paris where he created *Love on the Left Bank*, his most celebrated work.

Hripsime Visser is a curator at the Stedelijk Museum in Amsterdam. She has organized exhibitions and written widely on the work of contemporary photographers including Lewis Baltz, Gabriele Basilico and Thomas Struth.

Phaidon Press Limited
Regent's Wharf
All Saints Street
London N1 9PA

Phaidon Press Inc.
180 Varick Street
New York NY 10014

www.phaidon.com

First published 2002
©2002 Phaidon Press Limited

ISBN 0 7148 4077 7

Designed by Julia Hasting
Printed in Hong Kong

Photographs reproduced with kind permission of the Netherlands Photo Archives. With special thanks also to Anneke Hilhorst and Martijn van den Broek for the picture selection. Prints made by Hans Bol, Ooij (NL).